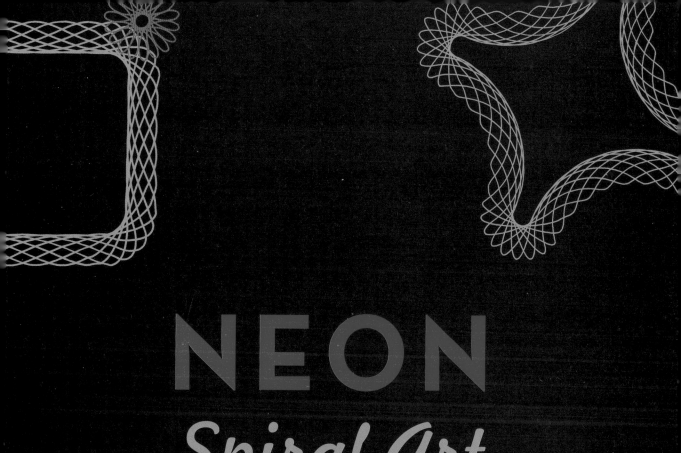

NEON

Spiral Art

Spin Colorful Geometric Designs

D1360336

PAUL BECK

Brimming with creative inspiration, how-to projects, and useful information to enrich your everyday life, Quarto Knows is a favorite destination for those pursuing their interests and passions. Visit our site and dig deeper with our books into your area of interest: Quarto Creates, Quarto Cooks, Quarto Homes, Quarto Lives, Quarto Drives, Quarto Explores, Quarto Gifts, or Quarto Kids.

© 2020 Quarto Publishing Group USA Inc.

Published in 2020 by becker&mayer! books, an imprint of The Quarto Group, 11120 NE 33rd Place, Suite 201, Bellevue, WA 98004 USA.

www.QuartoKnows.com

becker&mayer! books titles are also available at discount for retail, wholesale, promotional, and bulk purchase. For details, contact the Special Sales Manager by email at specialsales@quarto.com or by mail at The Quarto Group, Attn: Special Sales Manager, 100 Cummings Center Suite 265D, Beverly, MA 01915 USA.

21 22 23 24 25 6 5 4 3 2

ISBN: 978-0-7603-6855-8

Library of Congress Cataloging-in-Publication Data available upon request.

Author: Paul Beck

Printed, manufactured, and assembled in Shenzhen, China, 12/20.

Distributed by:
Quarto UK, The Old Brewery
6 Blundell Street, London N7 9BH, UK
Allen & Unwin
30 Centre Rd, Scoresby VIC 3179, AUS

Image credits: Page 14: Spiral Petroglyph ©Jason Cheever/ Shutterstock; Ancient apulian Olla ©Dario Lo Presti/ Shutterstock; Newgrange entrance with view of the famous Triple Spiral ©UnaPhoto/ Shutterstock; Detail of Book of Durrow: Courtesy of Trinity College Library: The Yorck Project: Public Domain. From Book of Durrow (7th Century); Page 16: Woven basket showing spiral pattern ©Bildagentur Zoonar GmbH/ Shutterstock; Piazza del Campidoglio: ©Campidoglio: Rome: Italy / Alinari / Bridgeman Images; Spiral Jetty ©Eric Broder Van Dyke/ Shutterstock; Desert Breath: Courtesy of Google Earth; Page 18: Harmonograph; A printout created by a pintograph. Public Domain; Henry's machine, Public Domain; Page 21: World's smallest snail: Courtesy of B. Páll-Gergelyand N. Szpisjak; Orb-weaver spiderweb ©Richard P Long/ Shutterstock; Chambered nautilus shell: cut in half to show interior ©joingate/ Shutterstock; Large spiraling stairway ©marco52/ Shutterstock; Cyclone weather pattern ©Vladislav Gurfinkel/ Shutterstock; Spiral galaxy ©Triff/ Shutterstock. Design elements used throughout: Set of spirograph elements ©Evgeniia Speshneva/ Shutterstock; seamless ornametal patterns ©ExpressVectors/ Shutterstock; Set of 6 seamless patterns ©suummermadness/ Shutterstock.

#334745

CONTENTS

Introduction

Tracks + Gears + Ink = Art!

Congratulations! You're the owner of an infinite drawing kit. It may seem simple, but with just these components you can create beautiful and complex designs. Whether you're an experienced spiral artist or just starting out, this book will give you helpful tips, inspiring ideas, and instructions for 18 neon designs. And that's just the starting place for an endless variety of your own creations.

What's In the Kit

The neon inks make designs that really pop! Add extra dazzle by using two colors for your combination patterns. And for the ultimate optical effect, try drawing on neon-colored paper.

Straight track (8)

90-degree curve (8)

45-degree curve (8)

Large circle gear

Medium circle gear

Small circle gear

Triangle gear

Football gear

Pens (2 colors)

Extras

- Paper, of course.
- A piece of corrugated cardboard or other drawing surface you can stick pins in.
- Thumbtacks (okay), push pins (better), or map pins (best). If you use thumbtacks, the heads should be no bigger than the width of the track pieces.

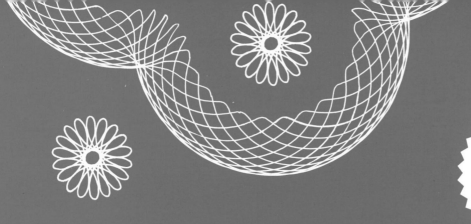

A NEW TWIST ON A CLASSIC TOY

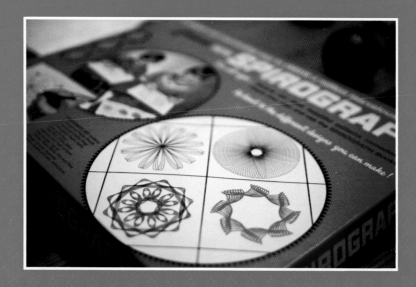

Although it wasn't the first drawing machine for creating spiral art, the rings-and-gears system goes back to 1962, when a British engineer named Denys Fisher went to work designing and perfecting his invention. It wasn't till 1965 that the device went on sale in England. Fisher named his invention "Spirograph," after the spiraling patterns created by the gears. It was a huge success. Spirograph drawing sets are still being made and sold today.

Laying Down Tracks

You'll be using five different track configurations to create the designs in this book.

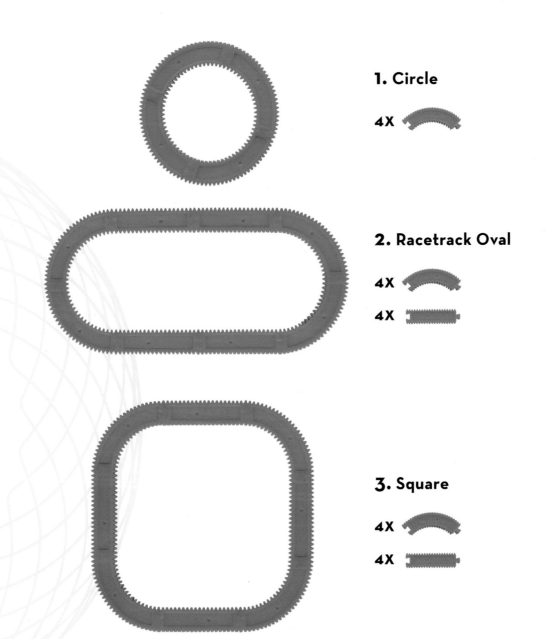

1. Circle

4X

2. Racetrack Oval

4X

4X

3. Square

4X

4X

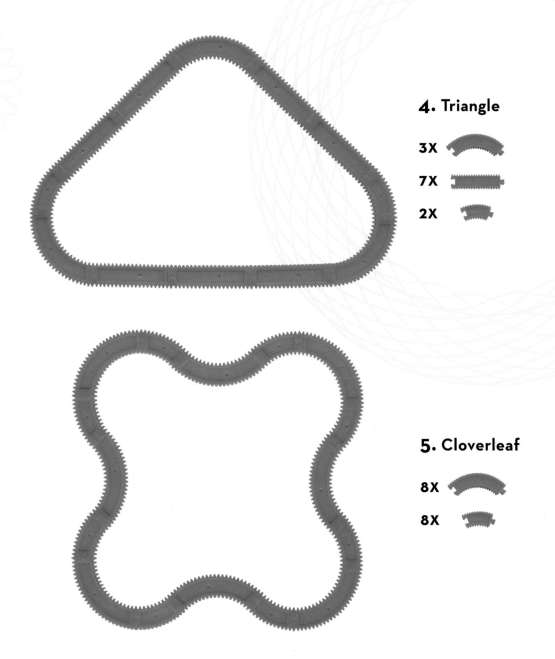

4. Triangle

3X

7X

2X

5. Cloverleaf

8X

8X

GET CREATIVE

These are just the tracks used in the designs in this book. Try inventing your own! Any track that's a closed loop can be used to create spiral art.

Let's Draw!

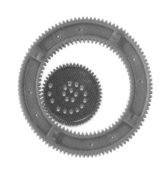

Start with the simplest track you can make. Take four of the 90-degree curves and snap them together to form a circle, like this:

Take this track and the medium circle gear, choose a pen, and you're ready to draw!

- Hold the track in place on the paper.

- Put the circle gear inside the track, making sure the side with the raised star is facing up.

- Push the gear into the track so the teeth are engaged.

- Put the pen in hole no. 12 counting out around the spiral from the *outside* of the gear.

- Keeping the track in place with your fingers, use the pen to run the gear around the inside of the track, drawing as you go.

- Keep going until the pen gets back to its starting point.

- Move everything out of the way and admire your first drawing!

The instructions will refer to the pen holes by number. Count the number of holes from the outer edge of the gear. Hole no. 1 is the closest to the edge, and the numbers go up as you move toward the center.

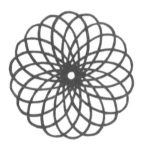

DRAWING TIPS

Get the best results with the instructions in the rest of the book!

- Make sure the track is flat, with all pieces snapped together evenly.

- Pin the track in place when using large tracks or drawing on the outside of any track.

- Keep the pen completely upright as you draw.

- Move the gear along smoothly. You may want to help it around with your non-drawing hand.

For your next drawing, use the small circle gear to draw around the outside of the square track. It's next to impossible to hold the track in place while you do this. You'll need to pin it down with map pins, push pins, or thumbtacks. Pin them through the holes in the tracks.

- Start with the square track.
- Use the small circle gear, hole no. 6. Remember, start counting the holes from the *edge* of the gear. Place the gear on the outside of the track and engage the teeth. Put the pen in the hole and roll the gear around the track till you end up back at your starting place.

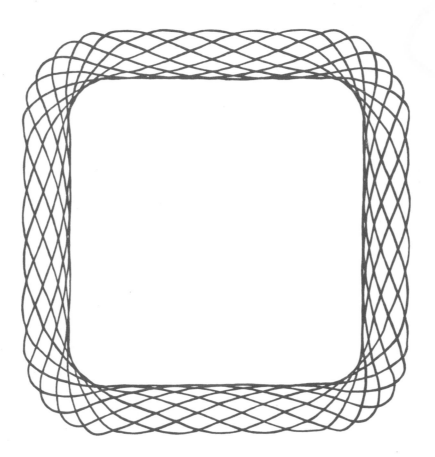

Here's a variation on the previous pattern, this time using both the inside and outside of the track. You'll definitely want to pin the track in place for this one.

- Square track
- Draw the inner pattern on the inside of the track with the medium circle gear, using hole no. 4.
- Leave the track in place and draw the outer figure using the same gear and hole, this time on the outside of the track.

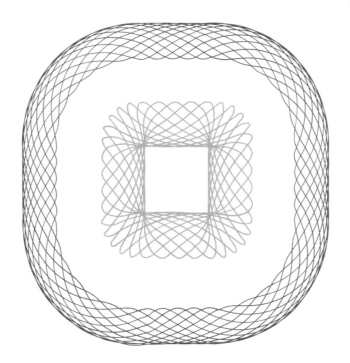

GET CREATIVE!

For variations on this drawing, try using different holes in the gear. Holes near the outside produce very different patterns from the ones in the center.

Art and Geometry

Believe it or not, when you create spiral art you're doing geometry. Your pen is tracing the path followed by a point (the hole) inside the gear as it travels along the track. Mathematicians call this kind of shape a *roulette*. It's the design created by tracing the path of a point inside a shape as it rolls along a line or curve. The simplest kind of roulette is created by a point on the edge of a circle as it rolls along a straight line:

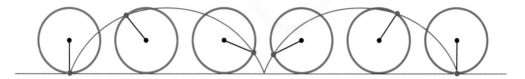

If the rolling shape is a circle, the traced shape is called a *trochoid* (TROH-koyd). If it's rolling around the outside of another shape, like the track in your design, it's called an *epitrochoid*.

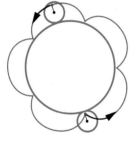

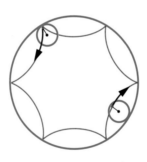

Epitrochoid Hypotrochoid

And if it's rolling around the *inside* of another shape, it's called a *hypotrochoid*.

So when you show your friends the drawing you just created, you can tell them that the title is "Roulettes." Then explain that it's composed of an epitrochoid with a hypotrochoid nested inside. They're sure to be impressed!

Rolling Circles

If you create an epitrochoid by rolling a circle around the outside of another circle, the shape you get depends on the relative sizes of the two circles.

If both circles are the same size and the traced point is on the edge of the rolling circle, the resulting shape is called a *cardioid* (meaning heart-shaped).

If the path is twice the diameter of the rolling circle, the shape is called a *nephroid* (NEFF-royd, meaning kidney-shaped).

The five-petal, flower-like shape is called a *ranunculoid*, from the scientific name of the buttercup.

Cardioid: diameter of
fixed circle = diameter
of rolling circle

Nephroid: diameter of
fixed circle = 2 x diameter
of rolling circle

Paths three, four, and five times the diameter of the rolling circle create these shapes:

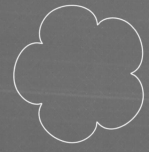

Diameter of fixed
circle = 3 x diameter
of rolling circle

Diameter of fixed
circle = 4 x diameter
of rolling circle

Diameter of fixed
circle = 5 x diameter
of rolling circle

If the relationship between the sizes of the path and the rolling circle isn't a nice, whole number, you get the interesting and complex roulettes created by your spiral art kit.

The rolling shape that creates a roulette doesn't have to be a circle. Here's a pattern using an unusually shaped gear.

- Circle track, outside path
- Football gear, hole no. 1

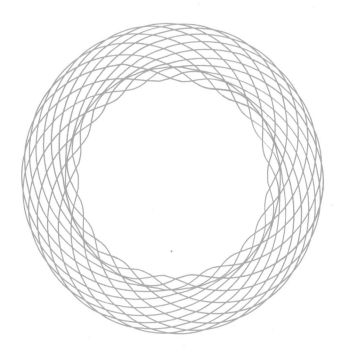

GET CREATIVE!

Try the same setup, but use one of the round gears instead of the football. Choose a hole that's a similar distance from the edge of the gear. Do you notice a difference in the shape of the path?

Spiral Art

Imagine holding on to the end of a long rope tied to a tree. Now imagine that you start walking around the tree, keeping the rope taut as you go. On top of that, imagine that you're dragging a stick behind you to scratch a line on the ground. As the rope winds around the tree, you'll draw a curved line that spirals (get it?) inward until you reach the trunk. That's a true spiral: a curve that tightens or widens around a central point.

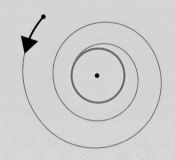

Spirals have appeared in art all over the world since ancient times.

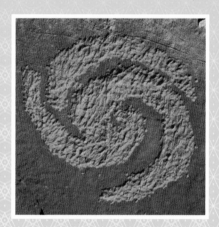

Spiral petroglyphs from Dinosaur National Park, Utah, USA

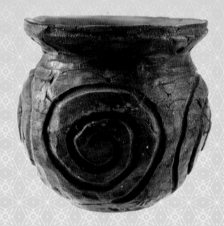

Ancient Greek spirals

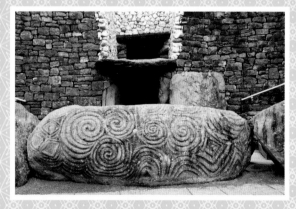

Prehistoric Irish stone carving

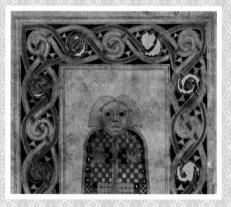

Medieval manuscript page with spiral border decorations

Using Two Gears

Here's a design that combines paths from two gears.

- Circle track
- Inside path: medium circle gear, hole no. 11
- Outside path: football gear, hole no. 12

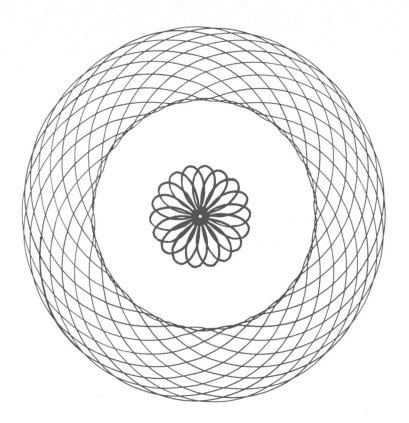

GET CREATIVE!

For a stained-glass effect, try filling in the open spaces
in your design with markers or colored pencils.

3-D Spirals

Basket Weave

Many baskets are woven from the center with a spiraling core. Different colors can be woven in to create amazing patterns.

Spiraling Piazza

The artist Michelangelo created the design for the Piazza del Campidoglio on the Capitoline Hill in Rome. Do you notice any similarity to your spiral art designs?

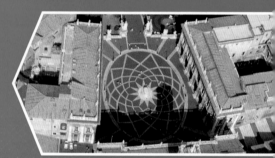

"Spiral Jetty"

Sculptor Robert Smithson created this 1,500-foot-long spiral of rock, salt, and mud extending from the shore of Utah's Great Salt Lake.

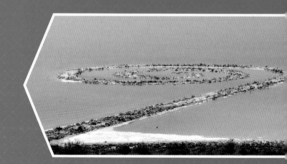

"Desert Breath"

Danae Stratou, Alexandra Stratou, and Stella Constantinides created this gigantic spiral sculpture in the Egyptian desert. Constructed out of the sand with cones and pits, the sculpture is titled "Desert Breath." It measures more than 1,000,000 square feet in area.

For more complex drawings, you can change the position of the track, as in this design.

- Circle track

Draw the large ring first:

- Small circle gear, hole no. 3, outside path

Now reposition the track to draw each of the four pinwheels:

- Medium circle gear, hole no. 6, inside path

GET CREATIVE!

Try the same drawing (or a variation) using different colors.

Art Machines

Your spiral art kit is part of a long tradition of mechanical drawing devices going back to the Victorian era. One of the most popular art machines of that time was the harmonograph. It drew designs using two swinging pendulums. A pen attached to one moved across a drawing board attached to the other. The motion of the two pendulums caused the pen to trace swooping, spiraling lines on the paper.

Illustration produced by a harmonograph

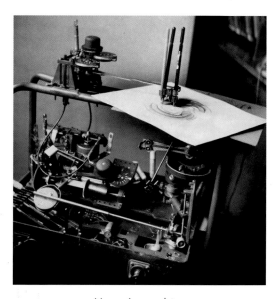

Henry's machine

In the 1960s, the English computer-art pioneer Desmond Paul Henry created art using an analog computer that controlled the movement of ballpoint pens on a sheet of paper.

Modern artists are still experimenting with machine drawing, sometimes with gigantic results. The artist Rosemarie Fiore mounted paint sprayers on a carnival ride called the Scrambler, then let it run. The Scrambler paintings look a lot like the drawings you're making, but they're 60 feet across!

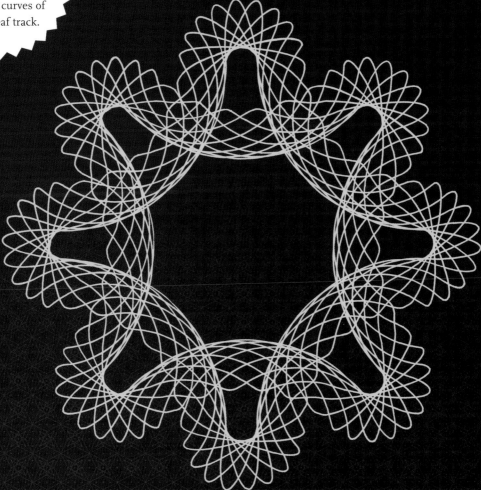

This impressive drawing looks complicated, but it's really just two copies of the same design, one on top of the other.

- Cloverleaf track, inside path
- Small circle gear, hole no. 1
- Pin the track down and draw the first pattern.
- Rotate the track 45 degrees (use the existing pattern as a guide) and draw the second pattern.

Incomplete Path

You've probably noticed some of the interesting patterns that appear while you're in the process of drawing, before the pen gets back to its starting place. You can always stop in the middle if you like what you see. This design is a nice example.

- Circle track, outside path
- Triangle gear, hole no. 5

Drawing Tip
To hide the beginning and end of the line, start and stop the pen on the outermost edge of the path.

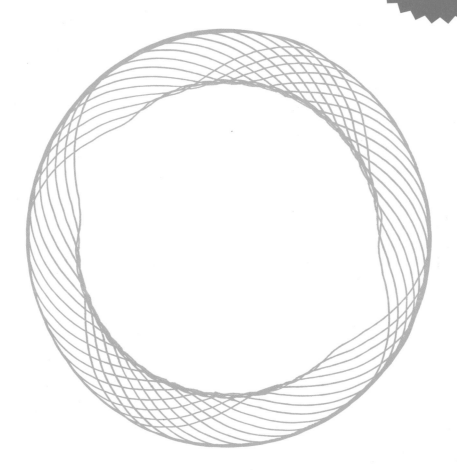

Look Around

The world around you is full of spirals, both natural and human-made, from microscopic to galactic. Keep an eye out for inspiration. The patterns you see may spark ideas for new ways to use your designs.

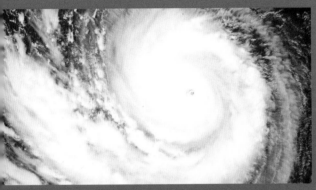

Weather patterns on Earth often form gigantic spirals.

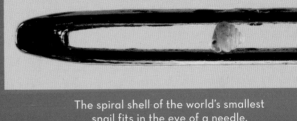

The spiral shell of the world's smallest snail fits in the eye of a needle.

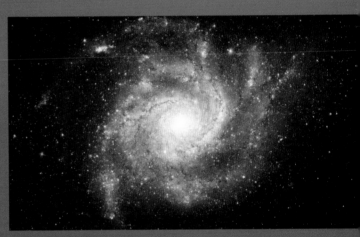

Spiral galaxy

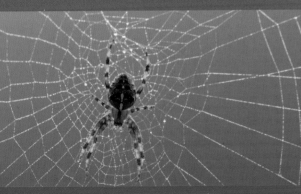

The orb-weaver spider spins its web in a spiral, working from the center outward.

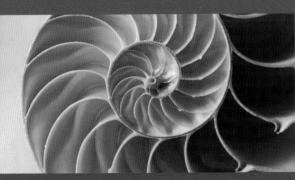

Chambered nautilus shell

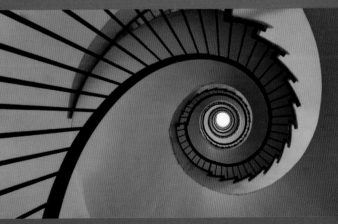

Spiraling stairs

New Tracks

Here are patterns for the tracks you haven't used yet.

- Racetrack oval
- Small circle gear, hole no. 1, both inside and outside path

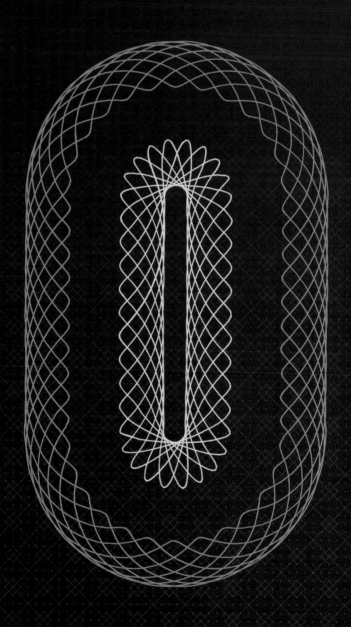

- Triangle track
- Inside path: medium circle gear, hole no. 4
- Outside path: large circle gear, hole no. 5

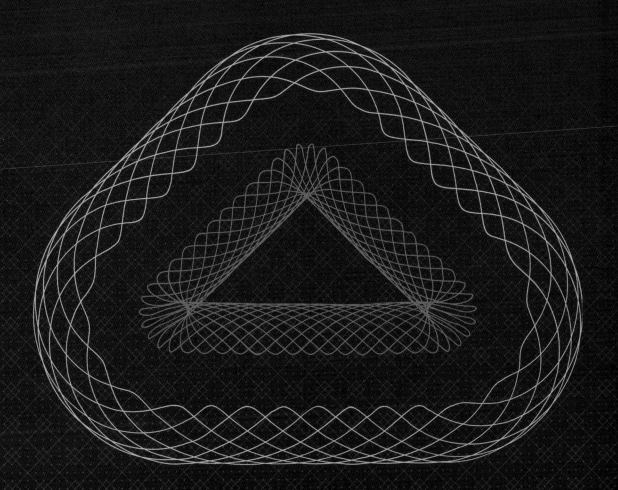

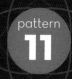
Here's a design with an incomplete path.

- Racetrack oval
- Inside path: medium circle gear, hole no. 3
- Outside path: large circle gear, hole no. 4, incomplete path
- To get this outer pattern, start the drawing with the pen (and hole) at the topmost point. Stop the drawing when the pen crosses this point again.

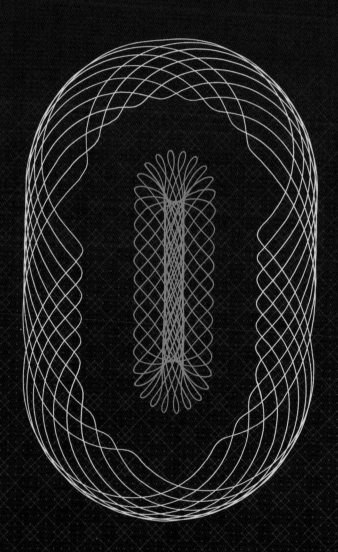

Eight-Pointed Star

Outer pattern:

- Square track, inside path
- Small circle gear, hole no. 6
- Draw one square pattern, then rotate the track 45 degrees to draw the second.

Inner pattern:

- Circle track, inside path
- Medium circle gear, hole no. 5

Cloverleaf Patterns

- Cloverleaf track
- Outside path: medium circle gear, hole no. 1
- Inside path: small circle gear, hole no. 5

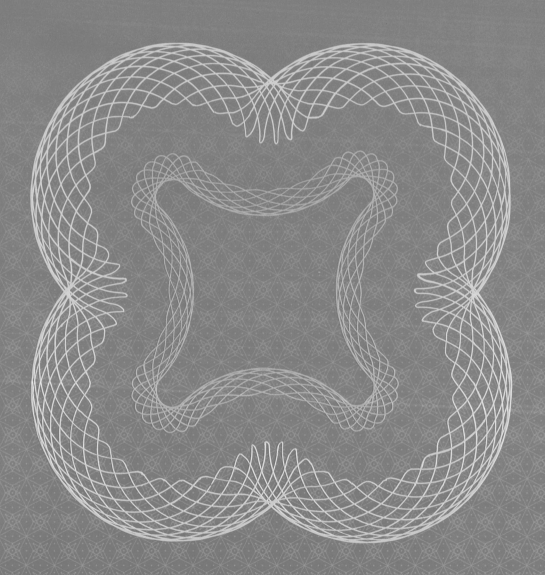

First, draw the magenta pattern:

- Circle track, outside path
- Triangle gear, hole no. 5

Then draw the orange pattern:

- Cloverleaf track, inside path
- Medium circle gear, hole no. 10

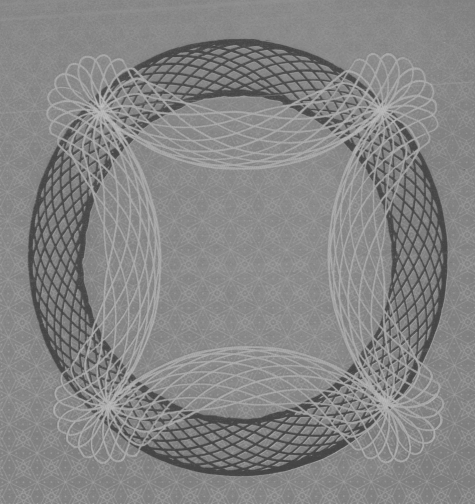

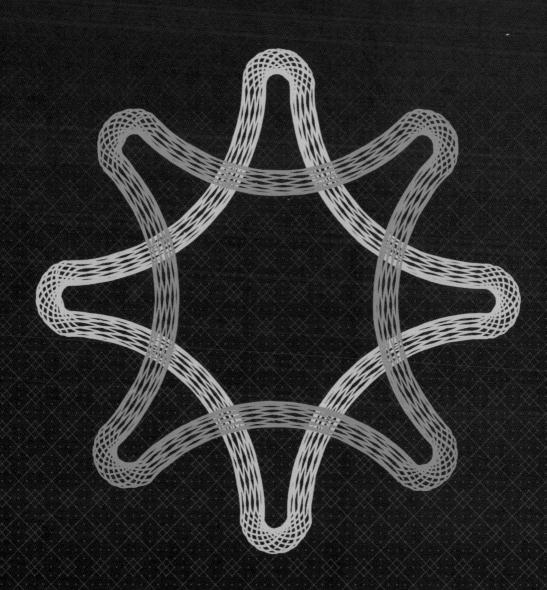

Overlay Patterns

- Cloverleaf track, inside path
- Medium circle gear, hole no. 17
- Draw the first pattern, then rotate the track 45 degrees to draw the second.

- Racetrack oval, inside path
- Small circle gear, hole no. 7
- First, draw the vertical pattern (or the horizontal one, if you prefer).
- Next, rotate the track 90 degrees and draw the second pattern perpendicular to the first.
- Rotate the track 45 degrees to draw the third pattern.
- Draw the fourth pattern in the spot that's left.

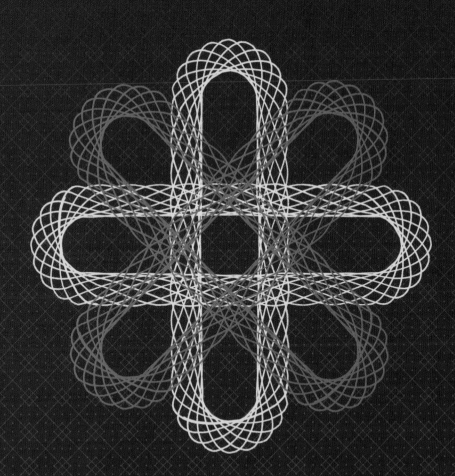

Super Spiral!

For an extra challenge, combine all the pieces into one enormous track!

Here are a couple of possibilities:

You can even build a wacky track like this one:

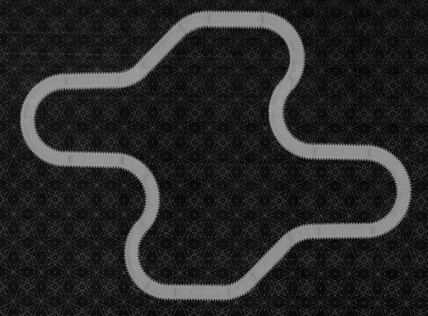

You can use it to draw this super spiral pattern. It will take all your spiral art skill to complete the drawing! Be extra careful in the curves so the gear doesn't slip. The one to use is the medium circle gear, hole no. 3. The circles in the middle are up to you to figure out. One of them is tricky!

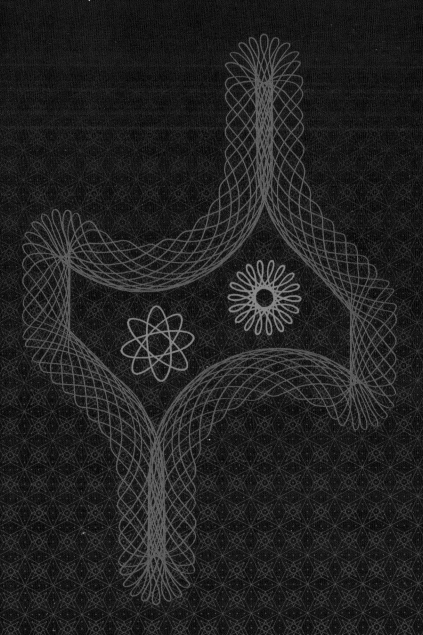

A Final Flower Design

Draw the outside pattern first:

- Square track, inside path
- Medium circle gear, hole no. 1

Next, draw the center pattern:

- Circle track, inside path
- Medium circle gear, hole no. 4

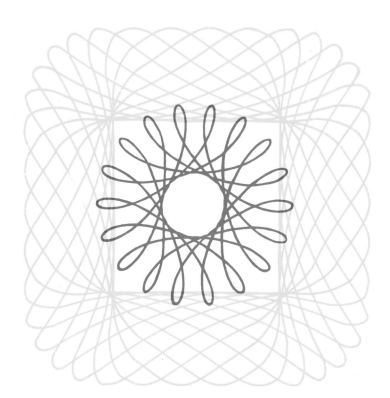

GET CREATIVE!

The patterns in this book are just a few of the infinite number of drawings you can create. Use these examples as a springboard for your own artistic creations. Try variations with different colors. Choose different gears or different holes. Add colors to the inner spaces in your patterns. Layer patterns on top of one another or combine them to create larger drawings. Invent your own track shapes. The possibilities are limitless!